**Royal Ontario Museum**

# ICONIC

## THE MUST-SEE TREASURES OF THE ROM

TESSA DERKSEN

Royal Ontario Museum
100 Queen's Park
Toronto, Ontario
M5S 2C6

www.rom.on.ca

Library and Archives Canada Cataloguing in Publication

Royal Ontario Museum
Iconic: the must-see treasures of the ROM / Tessa Derksen.

Issued also in French under title: Nos merveilles.
ISBN 978-0-88854-473-5

1. Natural history—Catalogs and collections—Ontario—Toronto. 2. Material culture—Catalogs. 3. Royal Ontario Museum—Catalogs. I. Derksen, Tessa. II. Title.

N910.T65A54 2009      508.074'713541      C2009-906439-1

Editors: Glen Ellis, Andrea Witmer
Copy Editor: Roxanne Covelo
Designer: Sheila Dalton
Production Coordinator: Virginia Morin
Photographer: Brian Boyle

Printed and bound in Canada by Transcontinental, Sherbrooke, Quebec

The Royal Ontario Museum is an agency of the Ontario Ministry of Culture.

Mixed Sources
Cert no. SW-COC-000952
FSC  © 1996 FSC

# CONTENTS

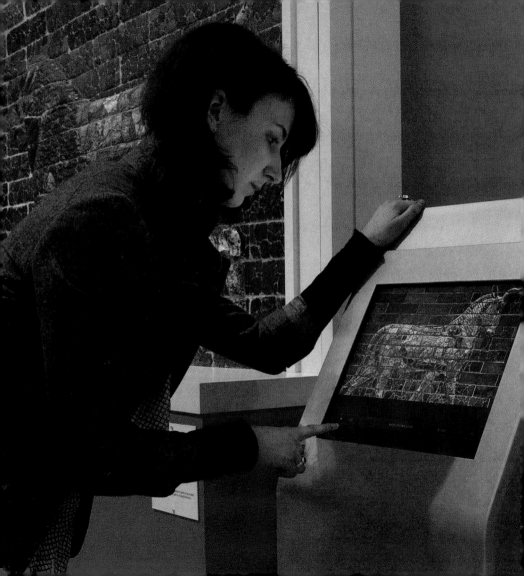

# FOREWORD

Every great museum has artifacts or specimens of unusual value, items of cultural or natural significance that symbolize the nature, quality, and values of the institution. These are the "must-see" objects that spring to mind as representing the museum itself. More iconic items may be added to the collections through new acquisitions. Visitors with limited time often ask to be directed to the ROM's special objects, both to see some of the world's great treasures and to understand the museum in which they exist.

The Royal Ontario Museum has created this special catalogue to provide more information on its star or "iconic" objects and to help locate those items within the museum's many galleries. Each of these treasures has a unique story of its history, significance, and acquisition.

This book is part of a larger initiative that includes audiovisual displays adjacent to each object. The project will ultimately include a downloadable audio tour. The various media are designed to work together to enhance accessibility to the artifacts and specimens and tell their stories.

We hope that you will find this book also to be of unusual value—as a guide to the ROM's iconic objects and as a memento of your museum visit.

Dr. Mark D. Engstrom
Deputy Director, Collections & Research,
and Senior Curator, Mammals

# INTRODUCTION

From the more than six million artifacts and specimens within the ROM's world cultures and natural history collections, a panel of curatorial experts chose 16 of the Museum's "star" objects. These jewels of the ROM range from a rare southern white rhinoceros to one of the best-preserved Chinese temple wall paintings in the world. Not all are exquisitely beautiful; in fact, many are quietly understated in their appearance. Yet all of the 16 are iconic in their rarity, cultural importance, and preservation.

The ROM's iconic objects are especially important for the contexts in which they reside. The *Nisga'a* and Haida totem poles represent family histories and commemorate family origins, rights, privileges, achievements, and experiences. The painting *The Death of General Wolfe* is part of several national histories, as well as the history of art, and its appreciation depends on some understanding of these facts. From the ancient Chinese temple mural *The Paradise of Maitreya* and the "Ming Tomb" to *Kunti* and the 900-carat *Light of the Desert* cerussite gem, the ROM's icons are enmeshed in wider worlds.

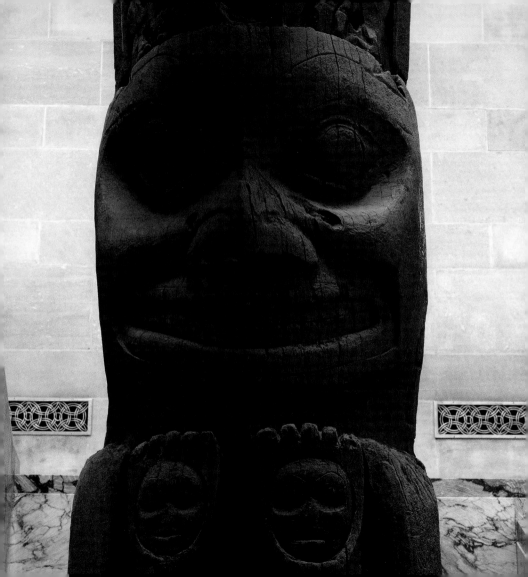

# Totem Poles

Date: 1860–1880, Material: Western red cedar, Accession numbers: Haida house frontal pole, 910 x 236; Nisg̱a'a memorial pole, 929.77.2; Nisg̱a'a mortuary pole, 929.77.1; Nisg̱a'a memorial pole, 928.70

The ROM's four totem poles of western red cedar were carved by the Nisg̱a'a and Haida of the Pacific Northwest Coast and display crests commemorating family origins, rights, privileges, achievements, and experiences.

Thought to have been carved between 1860 and 1880, the poles were first exhibited at the ROM in 1933 in a new building, the height of which had been dictated by that of the highest pole. The group consists of two memorial poles, a mortuary pole, and a house frontal pole.

The image of the flying frog hanging down and held by a human figure carved into the memorial pole from Gitlaxdamiks, Nass River, relates to the story of a woman who disappeared. She was later found and, because of the frogs that covered her body, frogs were adopted as crests by her clan.

The pole, erected by Eagle Chief Sagaẃeen around 1870 at the village of Gitiks, Nass River, reaches skyward to a height of more than 80 feet.

On the mortuary pole from Ank'idaa, Nass River, the images of Standing Bear and Ensnared Grizzly represent the story of the woman who married a bear and gave birth to human-bear cubs. Ensnared Grizzly was adopted as a crest and the pole was raised to commemorate a matriarch of high rank.

Emily Carr's 1913 painting *Tanoo*, in which the Haida house frontal pole appears, may give clues to the pole's original paint patterns.

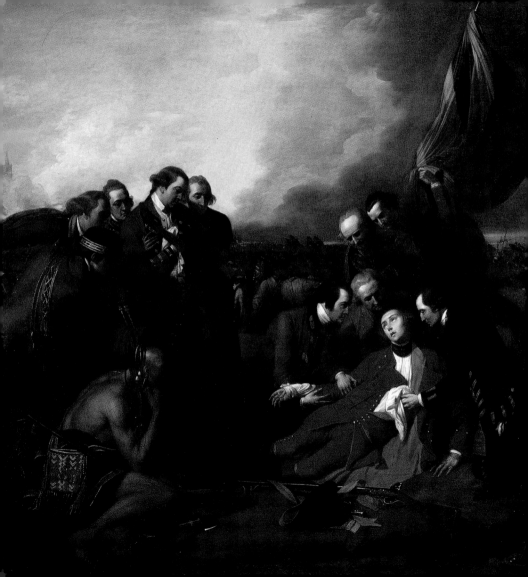

# *The Death of General Wolfe*

Date: 1776, retouched 1806, Material: Oil on canvas, Artist: Benjamin West, Accession number: 931.26.1 Purchased with the assistance of Col. Alexander Fraser

This famous document of Canada's military and colonial history is the last of five large versions painted by Benjamin West's own hand. It remained in the artist's London gallery until it was purchased at auction in 1829 by a descendant of Brigadier-General Monckton, Wolfe's second-in-command at Quebec.

A visual marker of the pivotal moment in 1759 when Britain could begin to claim New France as its own, the painting is not a realistic representation of the actual event as it contains figures we know were not present. Rather, it is a highly stylized version, infused with ideas of heroism, the idealized "noble savage," and even Christ-like undertones.

Since it first caused a sensation at the Royal Academy of London in 1771, *The Death of General Wolfe* has spawned countless copies, securing its status as an icon of Canadian history, and earning the American-born artist Benjamin West an international reputation. West was the first artist in the court of King George III to portray subjects in their "true clothes," as opposed to the classical tradition of clothing subjects in Greek and Roman dress.

After the battle, a boulder was rolled to the site of Wolfe's demise. Successive monuments have been erected over the years, including, most recently, a column outside the Musée national des beaux-arts du Québec, on the Plains of Abraham, bearing the inscription "Ici mourut Wolfe le treize Septembre 1759/ Here died Wolfe September 13, 1759."

etail

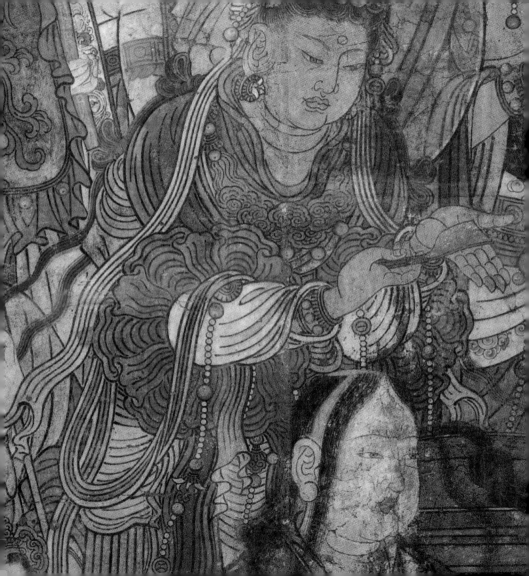

# The Paradise of Maitreya Mural

Date: 1298, Materials: Ink and colour on clay, Artist: Zhu Haogu, Accession number: 933.6.1
Bishop William C. White Collection
Gift of the Flavelle Foundation in memory of Sir Joseph Flavelle

This richly colourful mural, depicting an imagined heaven with Maitreya (Buddha of the future) as the central figure, is one of the best-preserved Yuan dynasty temple wall paintings in the world and the centrepiece of the ROM's renowned collection of Chinese temple art.

Painted more than seven centuries ago, *The Paradise of Maitreya* originally adorned the wall of a Chinese Buddhist monastery that no longer exists. This richly colourful mural was painted on an epic scale—more than 38 feet wide and almost 19 feet high. It depicts an imagined heaven with Maitreya, or Buddha of the future, as the central figure. Maitreya is surrounded by related deities, as well as a king and queen who are converting to Buddhism and becoming respectively a monk and a nun, represented here by the shaving of the royals' heads.

Few museums outside China have examples of such murals. The ROM's is one of the best-preserved Yuan dynasty (1271–1368) temple wall paintings in the world. Shipped in 1928, it arrived at the ROM in 63 sections and was painstakingly restored in 1933—you can still see where some of the sections were joined together.

In 2005 *The Paradise of Maitreya* received another much needed conservation treatment, restoring it to its full magnificence.

Detail

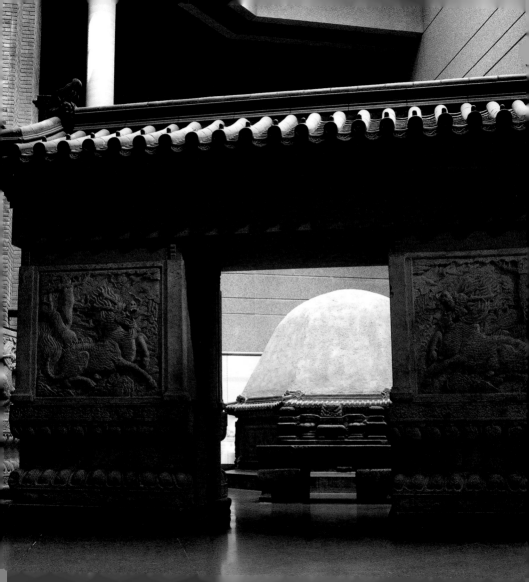

# Tomb Mound of General Zu Dashou ("Ming Tomb")

Date: 1656, Qing Dynasty, Materials: Marble and limestone (reconstructed earth mound), Accession numbers: mound, 919.1.26; gate, 919.1.24a–h; altar table, 919.1.27–28: camels, 919.1.29ab; military official, 919.1.30; civil official, 919.1.31. The George Crofts Collection

Generations of ROM visitors knew it simply as "the Ming Tomb." Recent research has revealed that this tomb with its large-domed burial mound at one time contained the remains of legendary Chinese general Zu Dashou (ca. 1565–1656).

Almost 90 years after this tomb was brought from the village of Yongtai, just north of Beijing, to Toronto, ROM research in China confirmed what had been only a rumour: the ROM's "Ming Tomb" had indeed contained the remains of famed Chinese general Zu Dashou and his three wives. General Zu Dashou's bravery and loyalty as a tireless defender of the Ming dynasty against the steadily advancing Manchus earned him a place in Chinese history similar to that held by General Wolfe in Canadian historical lore. To the Chinese, he is known as the comrade-in-arms of Yuan Chonghuan and the uncle of Wu Sangui, two other legendary heroes of the Ming-Qing war.

The general's story is not without tragedy —by the time the Ming imperial dynasty finally fell in 1644 and the Manchus established the Qing dynasty, most of General Zu's sons had switched loyalties and were fighting against him. In 1631 the general even gave one of his loyal sons to the enemy as a hostage, in an effort to expedite siege negotiations because people within the city he was defending were starving. This magnificent tomb, decorated with relief sculptures of auspicious myth-ological animals, was erected after the exiled general's death in 1656, an indication of the esteem in which he was held, even by his enemies.

Detail

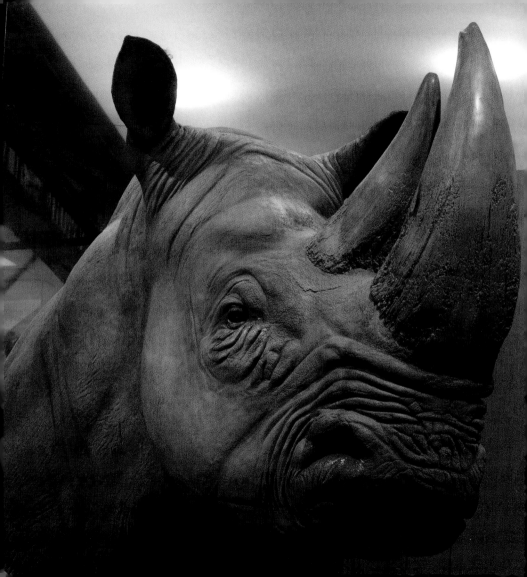

# Southern White Rhinoceros

Prepared February 2009, Accession number: MAM119469

Next to elephants, white rhinos are the second–largest land animal. At 11 feet long and weighing a mighty 4,500 pounds, this rare white rhino is an imposing figure at the entrance to the ROM's Schad Gallery of Biodiversity.

On February 26, 2008, the Toronto Zoo's oldest white rhino died at the age of 45. "Bull," as he was known, was born wild in South Africa in 1963, and lived at the San Diego Wild Animal Park for several years until being transferred to Toronto in 1974.

The southern white rhinoceros was once on the brink of extinction until a remnant population of approximately 50 individuals was discovered in Natal, South Africa, in 1895. These last remaining few were protected and the herd increased in numbers. Eventually, individuals of the species were placed in zoos around the world and were reintroduced to protected areas in southern and eastern Africa. This reintroductions have become a conservation success story.

Like the other four species of rhino in the world, however, the Southern White Rhino is still considered "endangered"— primarily because rhino horns remain highly prized illegal commodities and thus these large mammals must be given permanent protection. The horns are used in traditional Chinese medicine and are prized as dagger handles in the Gulf states.

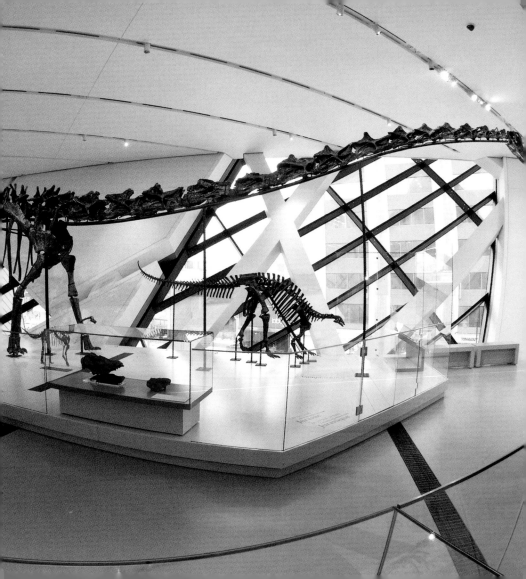

# *Barosaurus* ("Gordo")

Date: Late Jurassic Period (150 million years ago), Accession number: ROM3670

This skeleton of a rare, long-necked sauropod from the Jurassic Period is the largest dinosaur on display in Canada and the only *Barosaurus* skeleton in the world that contains actual fossil bones.

This rare specimen of one of the longest animals ever to walk the earth languished undocumented in the Museum vaults for nearly 45 years until a newly arrived palaeontologist, Dr. David Evans, discovered that the fossils once thought to be random bones from many different individuals actually belonged to a single skeleton. And not just any skeleton: it turned out to be an impressive 90-foot-long *Barosaurus*, a giant, long-necked sauropod from the Jurassic Period.

Nicknamed "Gordo," in honour of ROM curator Dr. Gordon Edmund who acquired the skeleton in 1962 from the Carnegie Museum, the *Barosaurus* is three times longer than the reticulated python, the longest reptile alive today. In life, this behemoth would have weighed as much as 33,000 pounds, the equivalent of three fully grown male African elephants. Gordo's skeleton is about half complete. What's amazing is that a skeleton of this size—Gordo's neck alone is 29 feet long— could survive virtually intact for millions of years. After a giant dinosaur such as this died, it would have been a veritable "all-you-can-eat buffet" for the carnivorous dinosaurs, and the chance of its skeleton being completely dismembered—and the individual bones carried away and not fossilized—would have been very high.

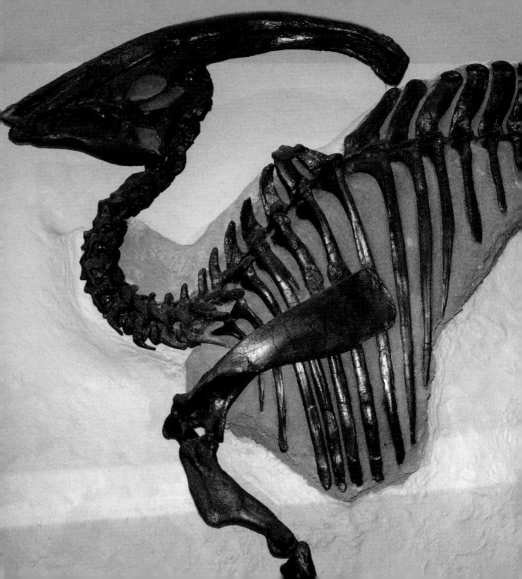

# *Parasaurolophus walkeri*

Date: Late Cretaceous Period (76 million years ago), Accession number: ROM768

This almost-complete skeleton of the duck-billed hadrosaur *Parasaurolophus walkeri* was the first specimen of the bizarre tube-crested plant-eater ever found, and it is still by far the best-preserved and most complete example of this iconic dinosaur.

The skeleton was discovered by a ROM expedition to the badlands of Alberta in 1920. The new species was introduced to the world two years later by palaeontology curator Dr. William Arthur Parks, who built the ROM's world-famous dinosaur collection. Parks is honoured by a bronze plaque outside the Museum. He named the species *Parasaurolophus walkeri* in honour of Sir Byron Edmund Walker, the ROM's first chairman of the board.

The long, tubular crest that projects from the back of its skull makes *Parasaurolophus* unique. The hollow crest contained greatly elongated nasal passages. The latest research on the function of these crests suggests that *Parasaurolophus* and other closely related dinosaurs used these structures to make low, bellowing calls to communicate with other members of their own species.

This specimen has been illustrated in countless books on dinosaurs, and exact replicas, cast from the ROM's original fossil, are on display in more than 30 major museums worldwide, including the American Museum of Natural History, New York, and the Natural History Museum, London, making *Parasaurolophus* one of the Royal Ontario Museum's most famous objects.

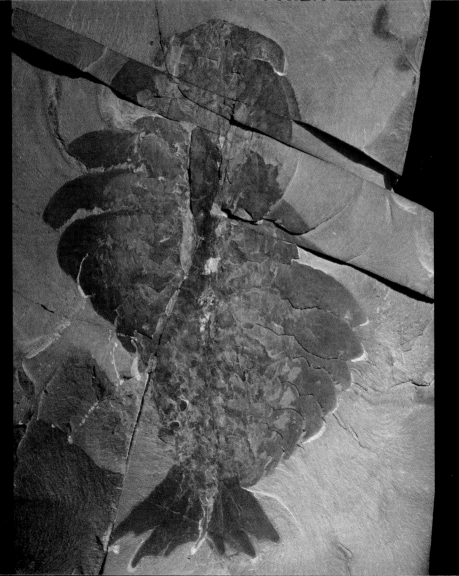

# Burgess Shale

Date: Middle Cambrian Period (505 million years ago), Accession number: ROM57720

The ROM houses an extensive collection of exceptionally well-preserved fossils from the half-billion-year-old Burgess Shale, a spectacularly rich fossil site in Yoho National Park in BC's Rocky Mountains. The fossils offer a rare window into a crucial phase in the history of early life on Earth and a glimpse at some of the most ancient and bizarre animals ever to inhabit our planet.

Lying entombed within the rocks are exquisitely well-preserved fossils of soft-bodied marine invertebrates that lived soon after the most important animal diversification in the history of life—the Cambrian Explosion. Most of the animals we know today are represented by early forms in the Burgess Shale.

The main Burgess Shale site was discovered more than 100 years ago by Smithsonian Institution palaeontologist Dr. Charles D. Walcott. During 18 field seasons, beginning in 1975, ROM field crews led by palaeontologist Dr. Desmond Collins amassed more than 150,000 specimens, making the ROM's collection of Burgess Shale fossils one of the largest and most diverse in the world, with more than 200 species from a dozen localities. New fieldwork and research by ROM palaeontologist Dr. Jean-Bernard Caron continue to provide important clues into the origin of today's animal diversity and this unique chapter in the history of life.

The specimen shown here, *Anomalocaris canadensis*, is distantly related to modern shrimps. A large but agile swimmer, it possibly reached up to a metre in length, making it the largest predator in the Cambrian Period.

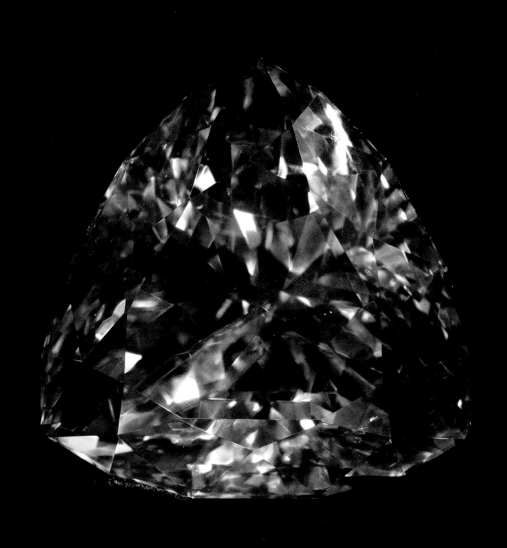

# *Light of the Desert* Cerussite Gem

Accessioned in 2000, Material: Cerussite, Accession number: M47982
Gift of the Louise Hawley Stone Charitable Trust

At 900 carats, this magnificent gemstone is the world's largest faceted specimen of the mineral cerussite.

Cerussite, a lead carbonate mineral, is extremely sensitive to heat and vibration—even warmth from the palm of a hand can damage it. Just imagine how much time and care the gem cutter must have taken to ensure that the inevitable heat generated during polishing and grinding wouldn't shatter this specimen.

The *Light of the Desert* was so named because of its dispersion (or fire) and for the deserts of Namibia, where it was found, and Arizona, where it was faceted. Dispersion, caused by the splitting of white light into the spectrum of colours, is even greater in cerussite than in a diamond. The *Light of the Desert*'s sheer size, precision faceting, and lack of inclusions (imperfections in the stone that inhibit the refraction of light) ensure its place as one of the world's most spectacular gemstones.

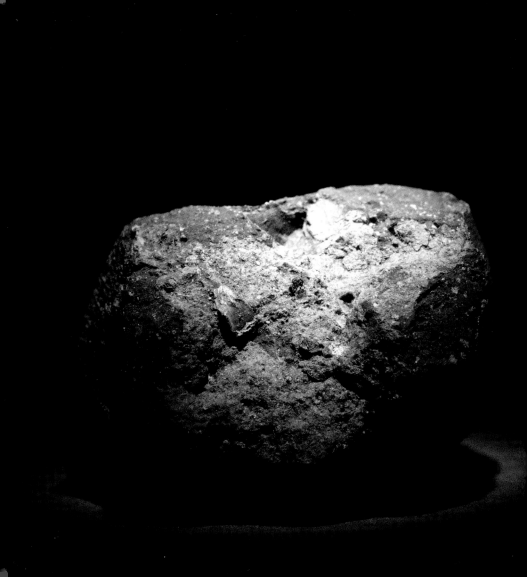

# Tagish Lake Meteorite

Impact date and time: January 18, 2000, 8:43 PST. Accession number: M52292
Purchased through a gift from the Louise Hawley Stone Charitable Trust and the Cultural Properties Export Review Board of Canada

This unassuming piece of porous black rock is a display fragment of what just might be the ultimate time capsule, a meteorite containing some of the oldest and most primitive organic compounds dating to the origins of our solar system, before the formation of the planets.

Of the thousands of meteorites that plummet to Earth each year, the Tagish Lake Meteorite was the first to be collected cold and remain frozen. After witnessing its fiery crash onto a frozen lake in northern British Columbia, quick-thinking amateur geologist Jim Brook rushed to recover samples and immediately stored them in his wilderness camp freezer.

By preserving the ice-cold temperature of the meteorite, the complex carbon-based chemical compounds contained within may also have remained frozen, as pristine as the day they formed more than 4.5 billion years ago, in the darkness of deep space. If this is true, the Tagish Lake Meteorite will be the first such sample available for scientific study, and may one day reveal answers about the beginnings of our solar system.

While most of the meteorite remains frozen and locked away for scientific research, a very small piece has been thawed and put on display at the ROM.

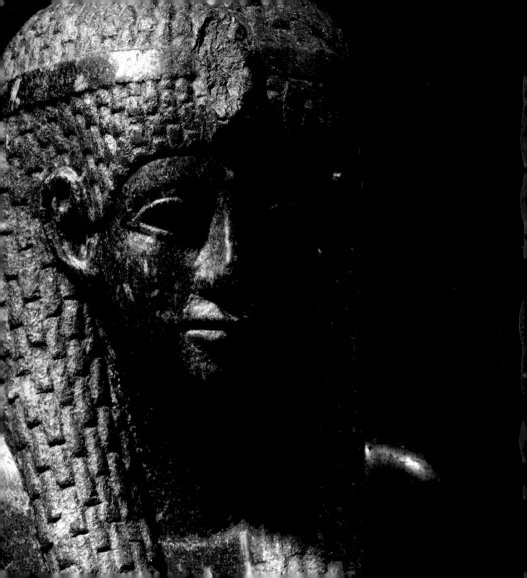

# Bust of Cleopatra VII

Date: 50–30 BC (Late Ptolemaic), Material: Granite, Accession number: 910.75

This rare and beautiful granite bust is most likely a very early representation of one of the most famous women in history—Cleopatra.

Once identified simply as "early Ptolemaic queen or goddess," this beautiful granite bust is now thought to be a likeness of Queen Cleopatra VII of Egypt.

The discovery of what is now being called a "missing link" was made through a serendipitous find by ROM Egyptologist Roberta Shaw. While reading a catalogue of the British Museum's exhibition *Cleopatra of Egypt*, Shaw noticed a photo of a female bust found in Alexandria that looked remarkably similar to the unidentified ROM statue, which had neither an inscription nor provenance. Shaw and Dr. Sally-Ann Ashton, Assistant Keeper at the Fitzwilliam Museum in Cambridge and a leading expert on Cleopatra, therefore relied on an art-history analysis.

The ROM's Cleopatra bears a strong resemblance to its Alexandrian counterpart: the same wig, the same features, and the same size. But the key feature that led to the ROM's statue's reassignment was the unusual back pillar and the attached crown.

The ROM's statue is now believed to be a very early representation of Cleopatra as Egyptian Queen, the Alexandrian statue a representation of Cleopatra as Egyptian goddess.

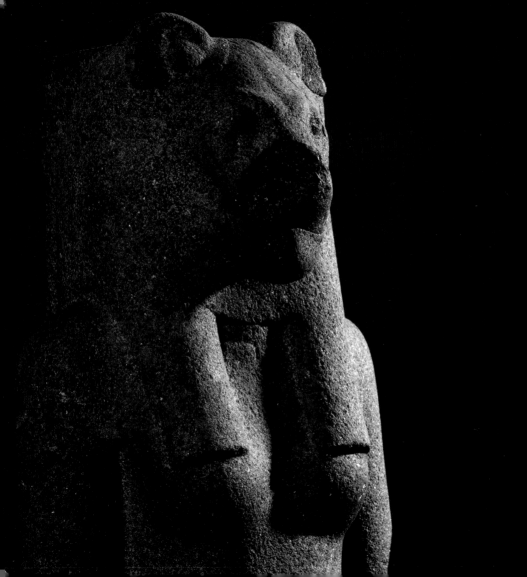

# Statue of Sekhmet

Date: ca. 1360 BC, Material: Granite, Accession number: 2007.68.1

This life-sized sculpture of the Egyptian lion-headed goddess Sekhmet—one of the oldest known Egyptian deities—most likely dates to the reign of King Tutankhamun's grandfather, Amenhotep III.

The pantheon of ancient Egyptian deities includes numerous animal-headed gods and goddesses, favourite subjects of sculptors. This statue of Sekhmet—a life-sized sculpture of the lion-headed goddess—is a very fine example of the genre. Most likely from the Mut temple at Karnak, the statue is well over 3,000 years old.

King Amenhotep III had such a penchant for Sekhmet that more than 700 statues of the warrior goddess are thought to have once stood in his vast funerary temple on the west bank of the Nile at Thebes.

The pharaoh may have commissioned the statues as a means of combating adversity, such as a plague. Sekhmet is mentioned numerous times in the spells of The Book of the Dead as both a creative and a destructive force. Her name, meaning "the (one who is) powerful," is fitting. Other titles point to different—sometimes terrifying—attributes, including the "Lady of Slaughter," which refers to a legend in which she is said to have slaughtered nearly all of humanity, until she was stopped by the sun-god, Re.

etail

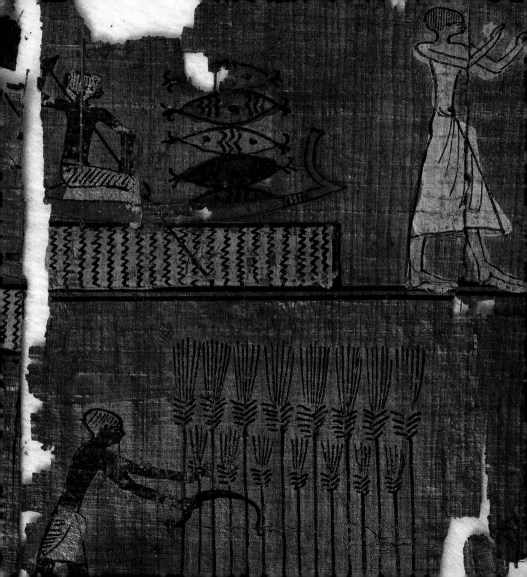

# Egyptian Book of the Dead

Date: 320 BC, Material: Papyrus, Accession number: 978.43.1 910.75

The prestigious University of Bonn Book of the Dead Project—a central registry for all known Book of the Dead papyri—recently judged the ROM's copy of this ancient Egyptian "self-help guide" for passage to the afterlife to be one of the finest specimens in the world.

Dating to about 320 BC, the book's artistic quality ranks among the finest of its day, and it is one of very few surviving examples to include extensive gold-leaf decoration. Most of the ROM's Book of the Dead, which measures an astonishing 19 feet long, has remained in storage for nearly a century. In May 2008, the Bonn Project's leading expert, Dr. Irmtraut Munro, travelled to the ROM and began a conservation project to restore the fragile papyrus to its original splendour. Six months later, the painstaking conservation work was complete.

Passage to the afterlife was full of danger and the possibility of "not making it" had to be counteracted with many spells intended to provide the spirit with what it needed to avoid such an unthinkable outcome. Some of the texts were directed against hostile forces that lurked in the darkness of the underworld, crocodiles and snakes for example. Other spells instructed the deceased on what to say "for entering by the mysterious portals of the House of Osiris."

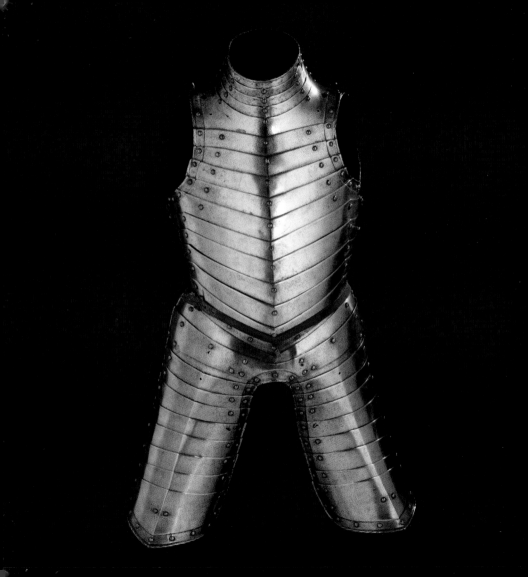

# Earl of Pembroke's Armour

Date: 1550s, Materials: Steel and leather, Accession number: 931.49.19.1

The ROM's Pembroke armour is a true work of artistic genius, combining functionality, superb craftsmanship, and elements of taste and fashion of the Tudor era.

This is the surviving part of an armour made at Henry VIII's famous Greenwich royal workshop by the great master armourer Erasmus Kirkener (1519–1574) for William Herbert (1501–1570), 1st Earl of Pembroke. It is cited in a 1558 inventory from Wilton House in Wiltshire.

Composed of overlapping horizontal lames of steel held together by internal leather straps and sliding rivets, the breastplate and backplate are of a type known as an "anime." Influenced by Italian design, animes played an important part in armour designed by Kirkener between 1550 and 1560. The ROM's anime is one of only three of those made at Greenwich that survive in public collections. Typically Kirkener's animes formed the core parts of armour "garnitures," with interchangeable parts added or subtracted for different purposes. The Pembroke armour in the ROM would have formed the main part of what was known as a "small garniture," which could be made up for infantry, and for light or heavy cavalry use.

The ROM's anime of the Earl of Pembroke shows affinities with fashionable dress of the 1550s—it has the same shaped waistline and silhouette of the civilian jacket or doublet. And more accurately than any painting or sculpture could have done, this custom-made armour records the physical dimensions of a Tudor aristocrat. Here, in the form of a steel exoskeleton, we encounter the real person who once wore the armour.

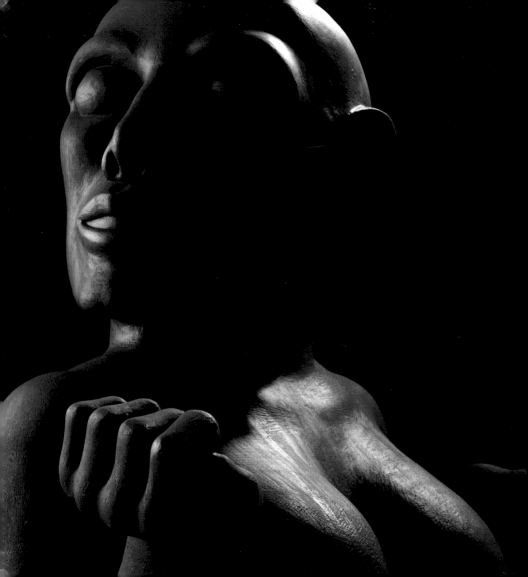

# *Kunti* Sculpture ("Blue Lady")

Date: 1999, Materials: Indigo and acrylic paint on teak wood, metal, Artist: Navjot Altaf,
Accession number: 2007.31.1.1–2, from the series "In Response to"
This purchase was made possible with the generous support of the South Asia Research and Acquisitions Fund and Talwar Gallery, New York City.

Painted a brilliant blue, this powerful female figure is a physical manifestation of contrasting dialogues about hand-crafted and industrial materials, the past and the present, modernism and traditional spirituality, and Western and South Asian world views.

Kunti is the name of a woman from Kondagaon, a village in Chhattisgarh, India, where the Mumbai-based artist Navjot Altaf lived and worked with Adivasi (indigenous) artists. This woman was an educated female who threatened the local patriarchal order and was therefore accused of being a witch. It is Kunti's story that inspired the artist to make this sculpture.

The sculpture's rounded figure and birthing pose reflect those of fertility goddesses from South Asia's artistic past. The colour alludes to the inequities of the indigo trade in colonial history but also suggests divinity, as some Hindu gods are often depicted with blue skin. The backward placement of the figure's thumbs references beliefs about witchcraft in village communities, while the position of her hands is a type of *mudra*, or symbolic gesture. This is not a traditional *mudra*, but a product of the artist's imagination, representing the receiving of knowledge in one (grasped) hand and its dissemination through the other (open) hand. This figure is sculpted from teak wood (an allusion to South Asian handicraft industries), yet she sits atop a mass-produced metal object, a replica of Marcel Duchamp's *Bottle Rack*, an iconic work from the history of Western modern art. By merging traditional and modernist styles with the theme of social justice, the artist challenges dominant narratives in society and art.

# Striding Lion Terracotta Relief

Date: ca. 580 BC, Material: Terracotta, Accession number: 937.14.1

This painted and glazed terracotta relief of a striding lion originally adorned the throne room façade of the palace of King Nebuchadnezzar II (604–562 BC) in Babylon.

Made of moulded bricks that were both painted and glazed, magnificent reliefs showing rows of striding lions, bulls, and dragon-like creatures adorned Babylon's public buildings during the reign of King Nebuchadnezzar II, most famously the Ishtar Gate with its grand "Procession Street." Only very few of them, such as the present piece, were found in the inner part of the king's palace, decorating the façade of its throne room. Since the reliefs were assembled in place, the position of each brick had to be planned ahead carefully. Each brick had to be fired before applying paint—black for outlines, white for body parts, ochre for the mane, blue for the background—and subsequently re-fired for glazing.

In addition to his building efforts at Babylon, which included the "Tower of Babel" and the "Hanging Gardens," Nebuchadnezzar captured and destroyed Jerusalem in 597 and 586 BC, sending the Jews into their "Babylonian Exile." References in the Book of Daniel to nightmares suffered by Nebuchadnezzar and to the ominous appearance of "Writing on the Wall" in Babylon's palace, both seemingly foretelling Babylon's demise in 539 BC, reflect the Bible's negative attitude towards Babylon's splendour, a sentiment that persists in Western traditions.

etail